This book is dedicated to
fashionable women everywhere
who celebrate being 40-ish.

Carmen McCullough is a mixed media collage artist who was inspired to create this book when she, and many of her friends, turned 40-ish.

The background images were created using paint, glue, and pattern tissue.

The fashionable outfits were inspired by Moda, Chrysalis fabric by Sanae. (For more info go to www.ModaFabrics.com).

You can contact Carmen at Carmen@StrangeFarmGirl.com. Or visit her website at www.StrangeFarmGirl.com.

The story you are about
to read is true.
Only the names
have been changed
to protect the innocent.

(Except for the woman
on page 16.)

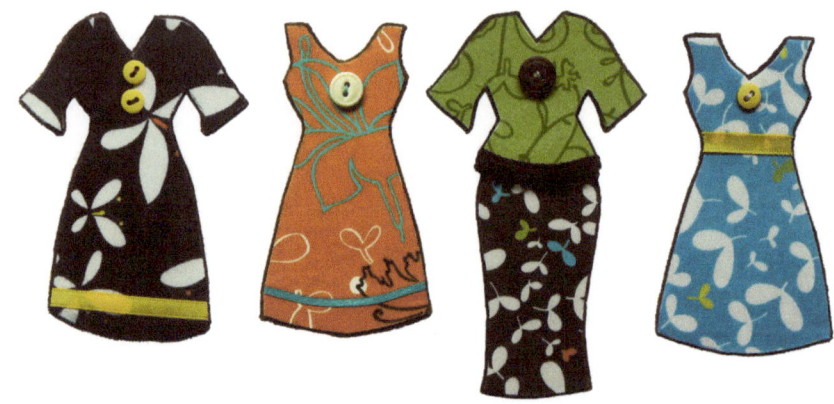

When she turned 40-ish...

Annette wrote her memoirs on the back of a paper bag.

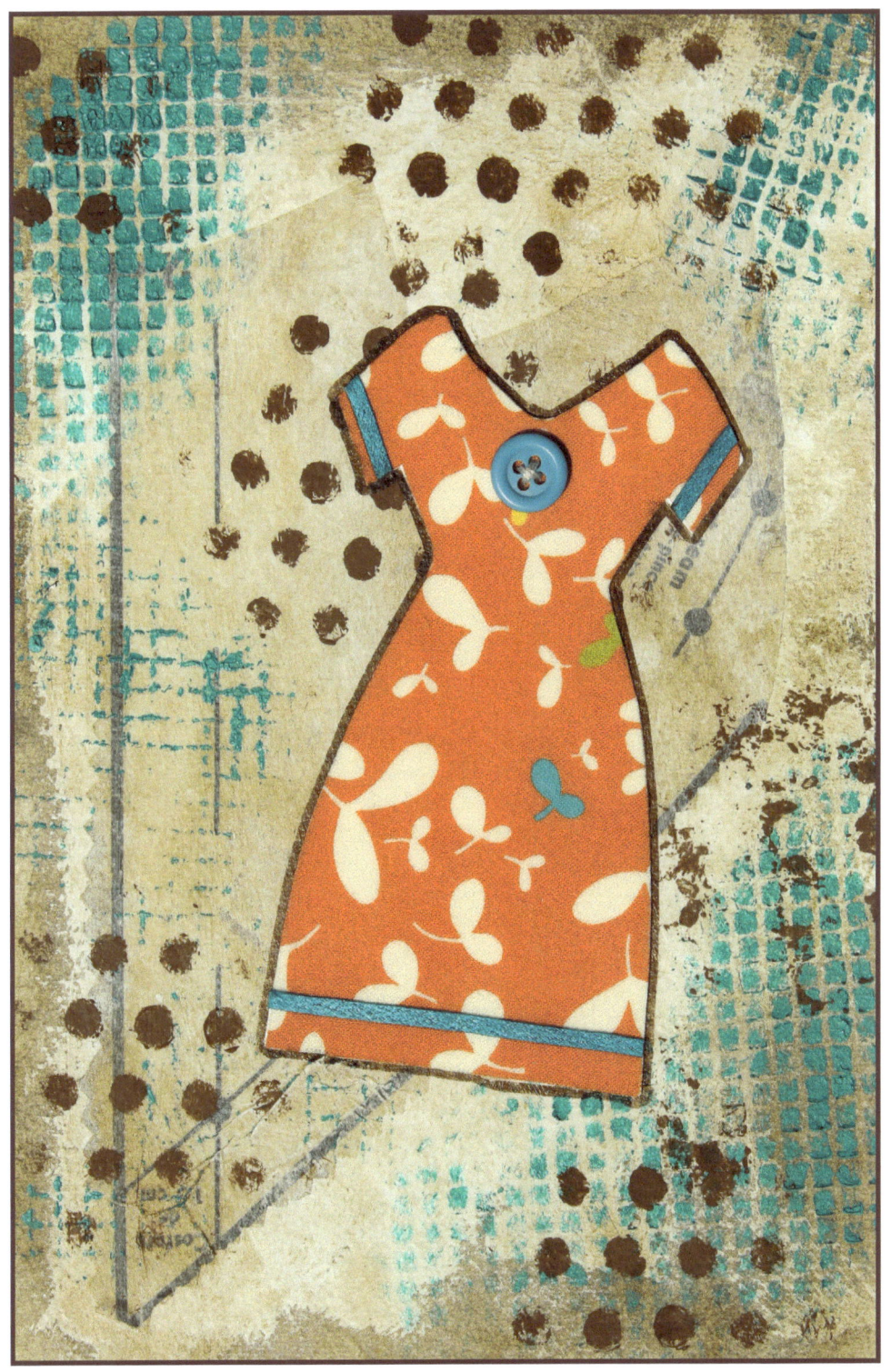

B

Bernice still didn't understand
the principles of economics,
and found she no longer cared.

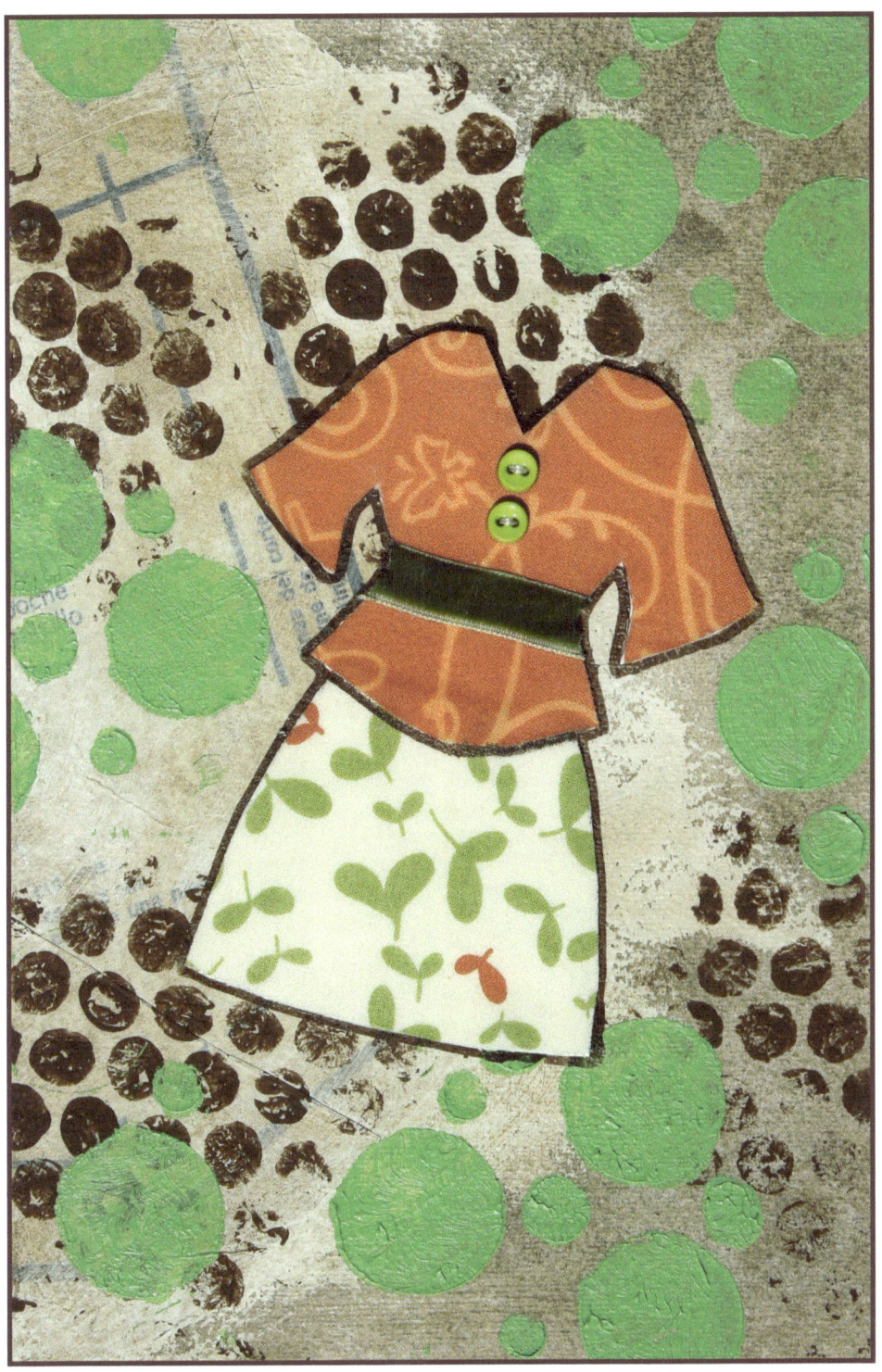

Carmen buried herself in cheesecake.

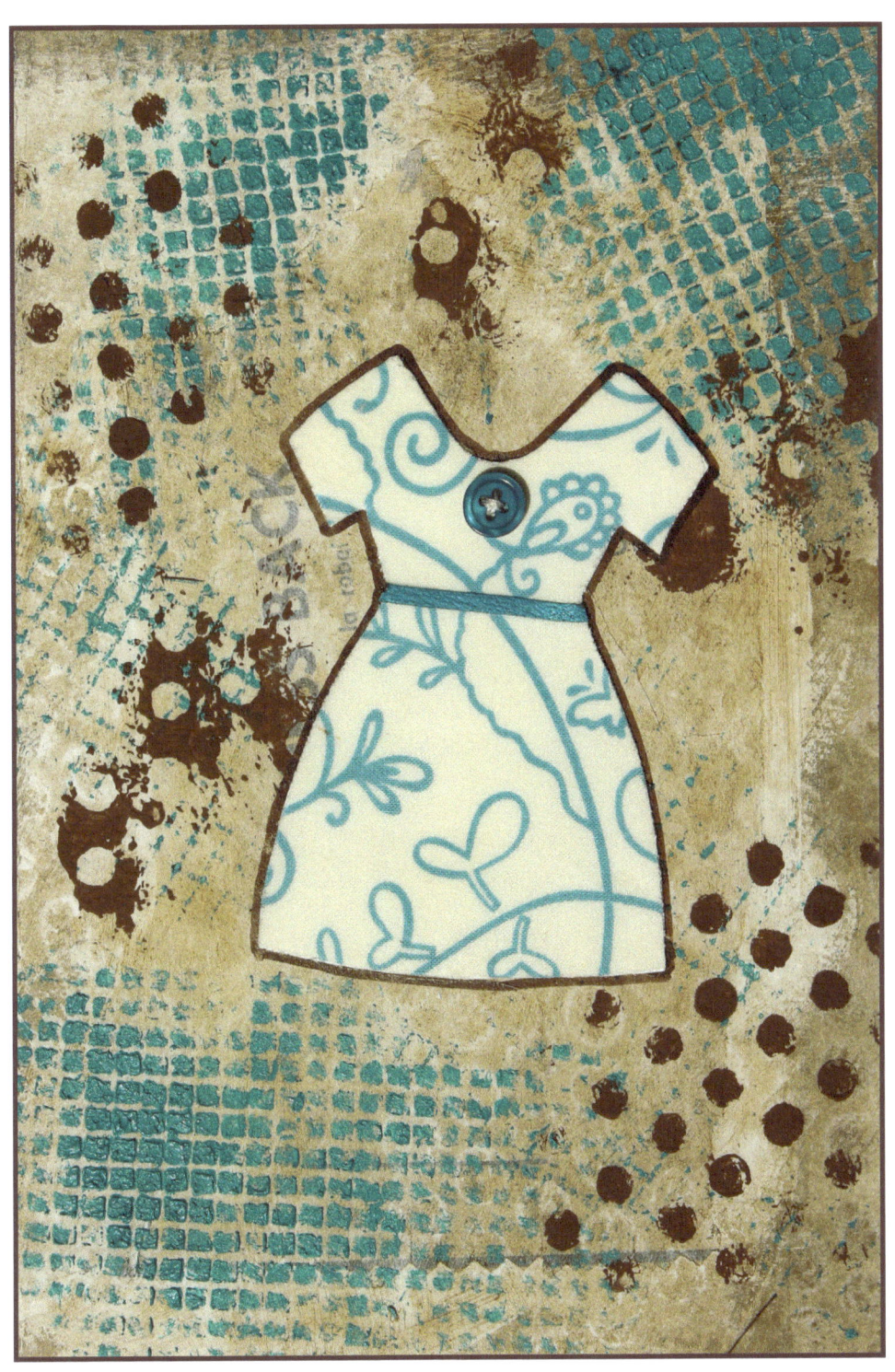

D

Deena burned her diary and journals.

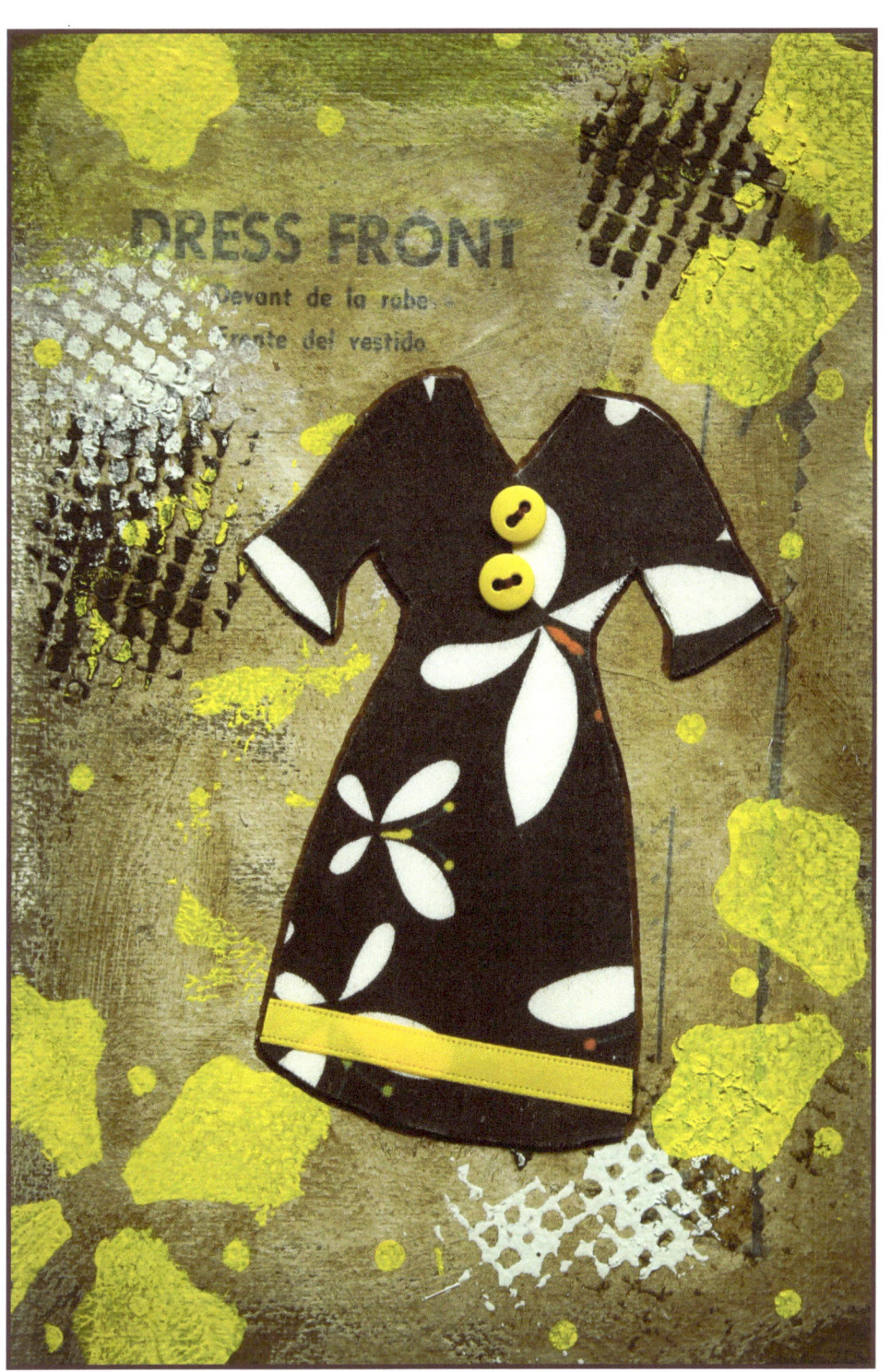

Elisa finally went to a Cher concert.

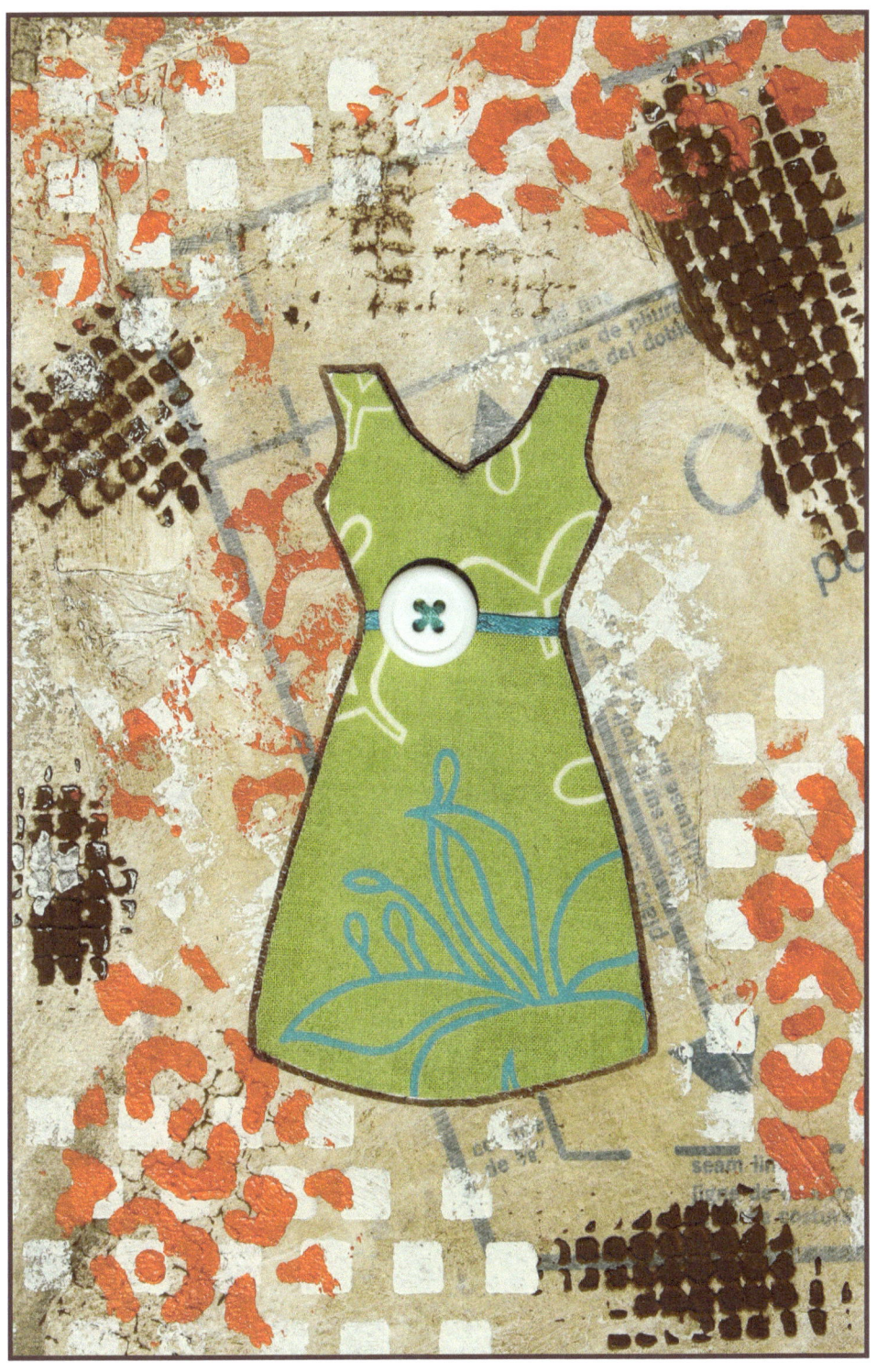

Francine began stalking writers at book-signing events.

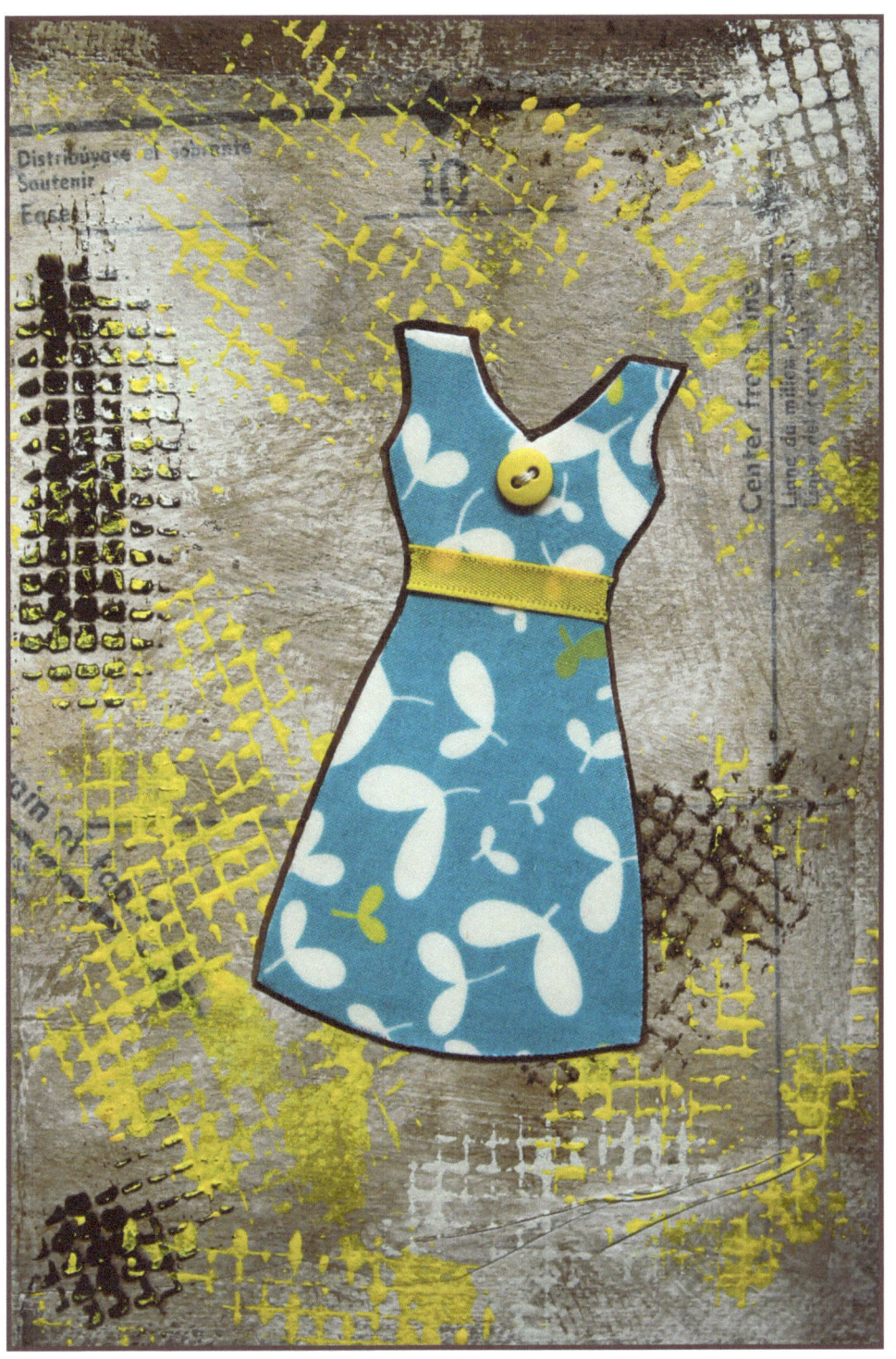

Greta realized she talked too much.

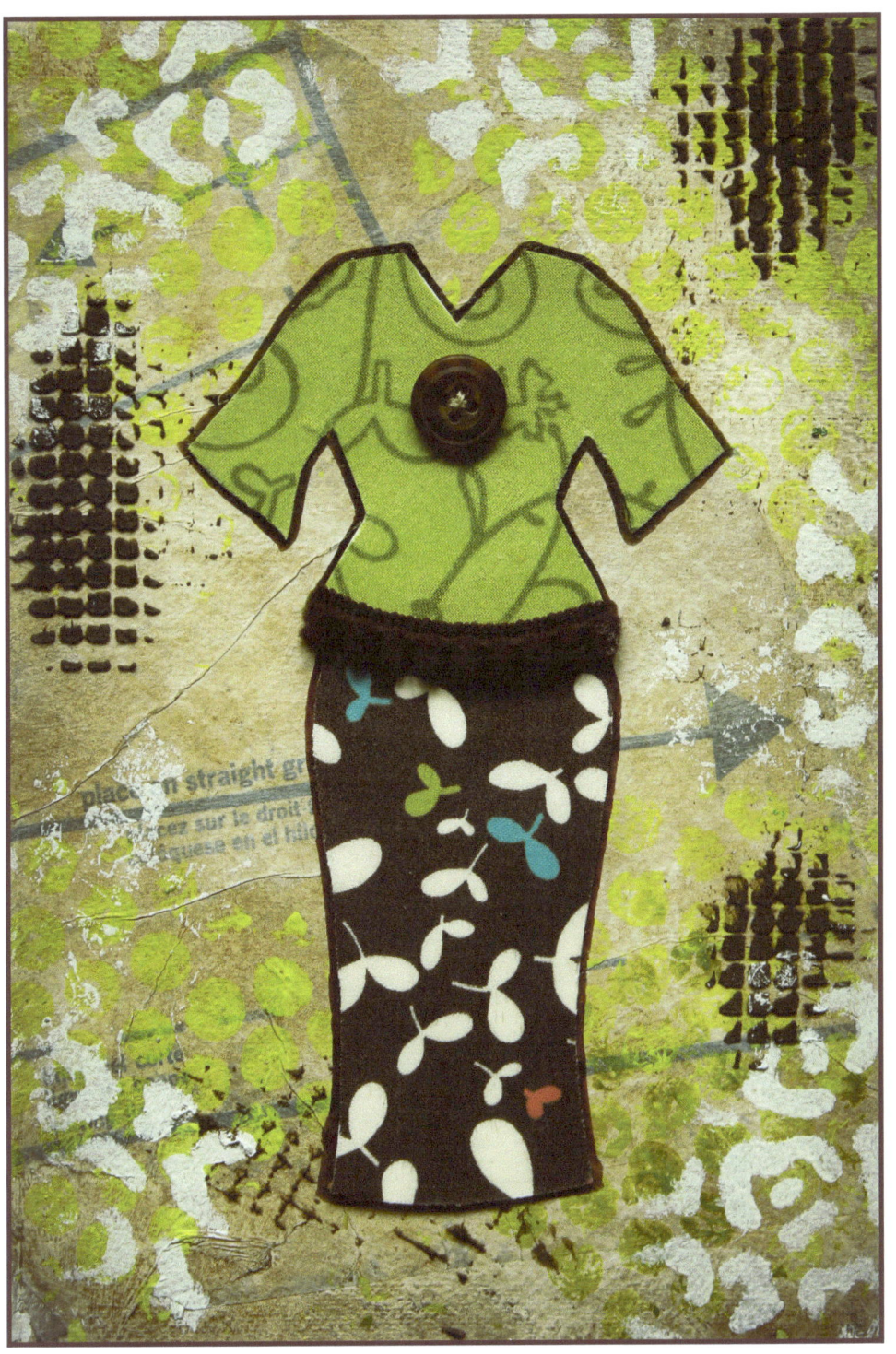

Hailey found she could no longer sleep without medication.

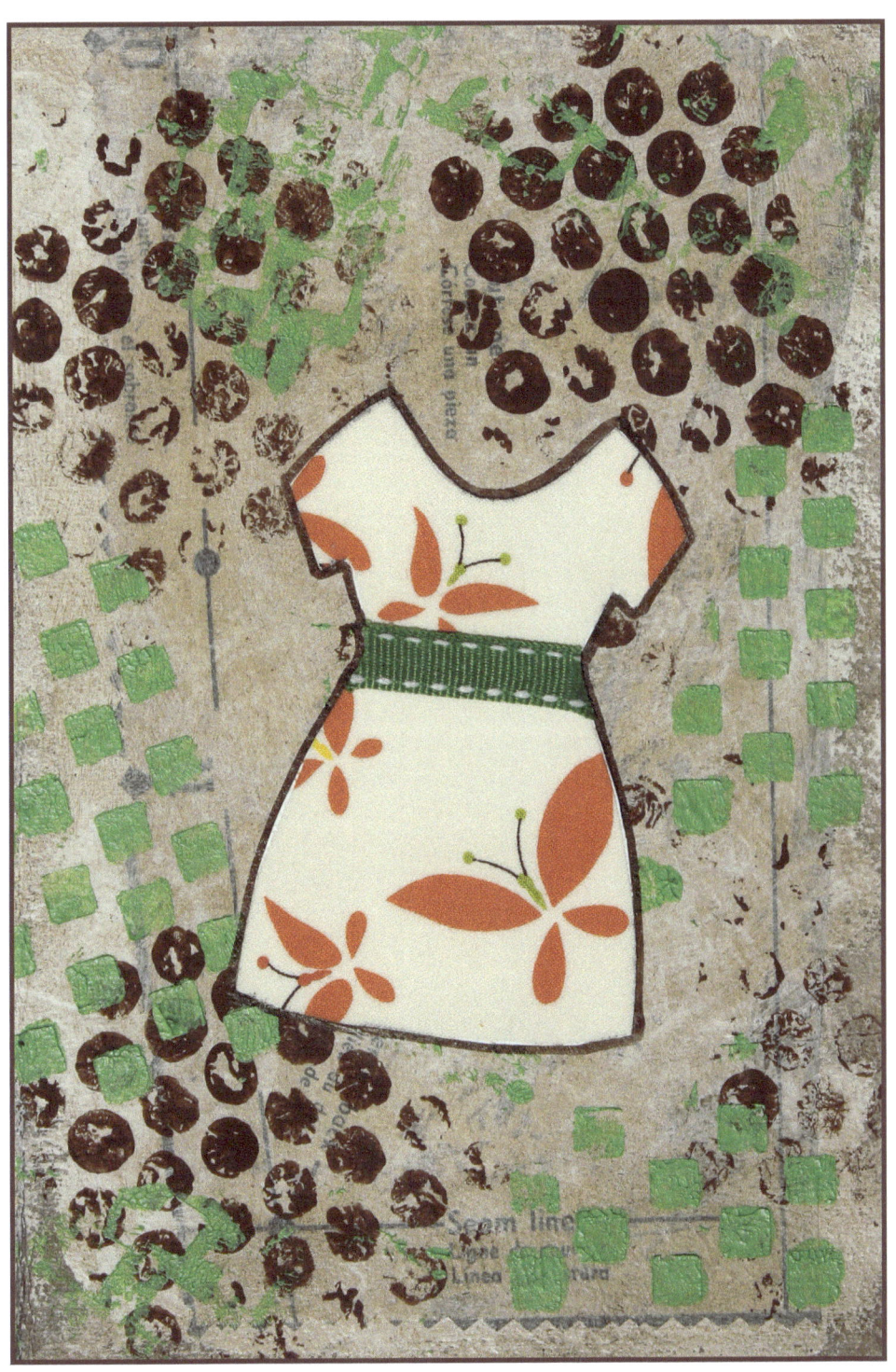

I

Ione got her first tattoo.

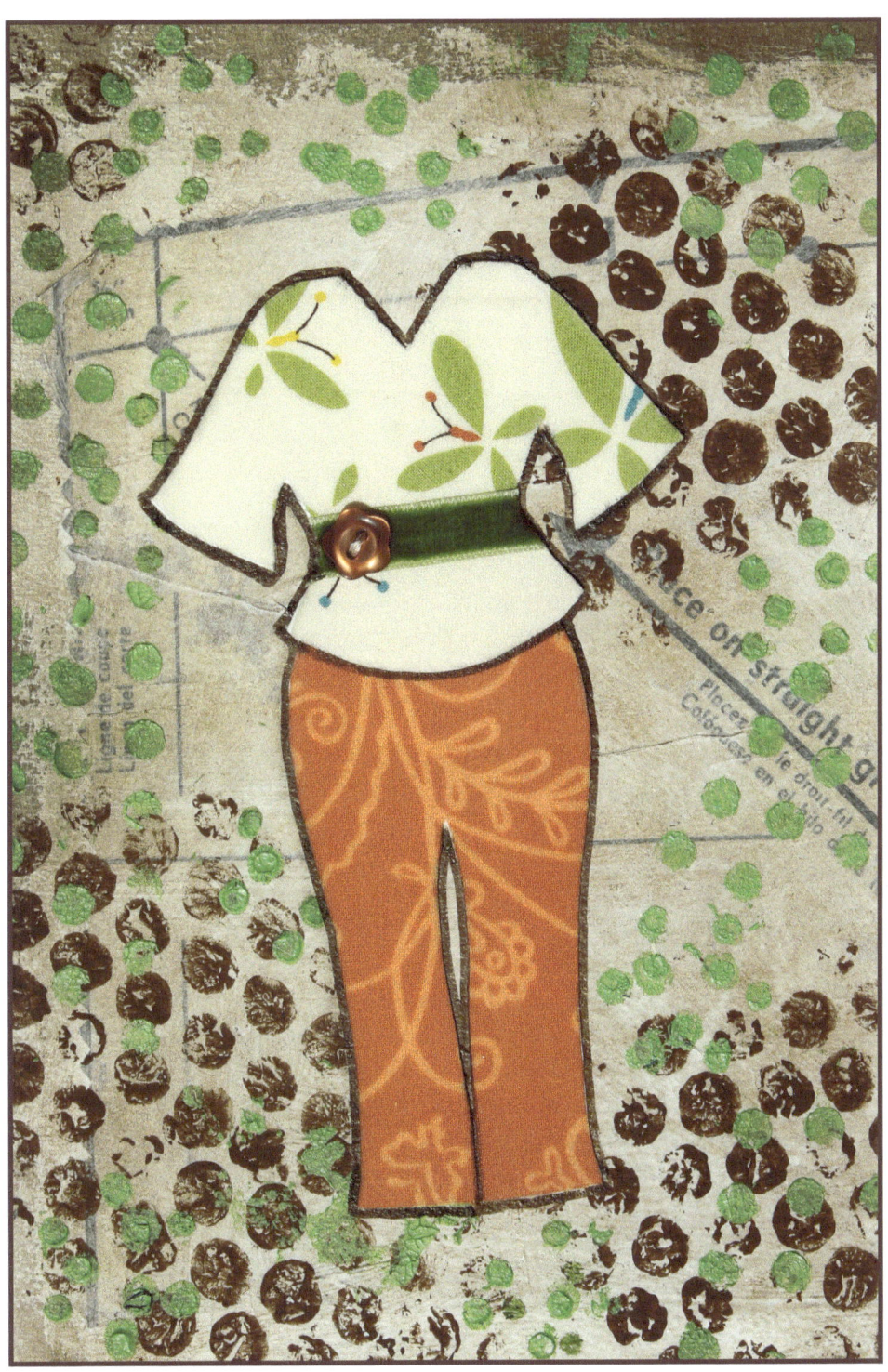

Jane began singing in karaoke bars.

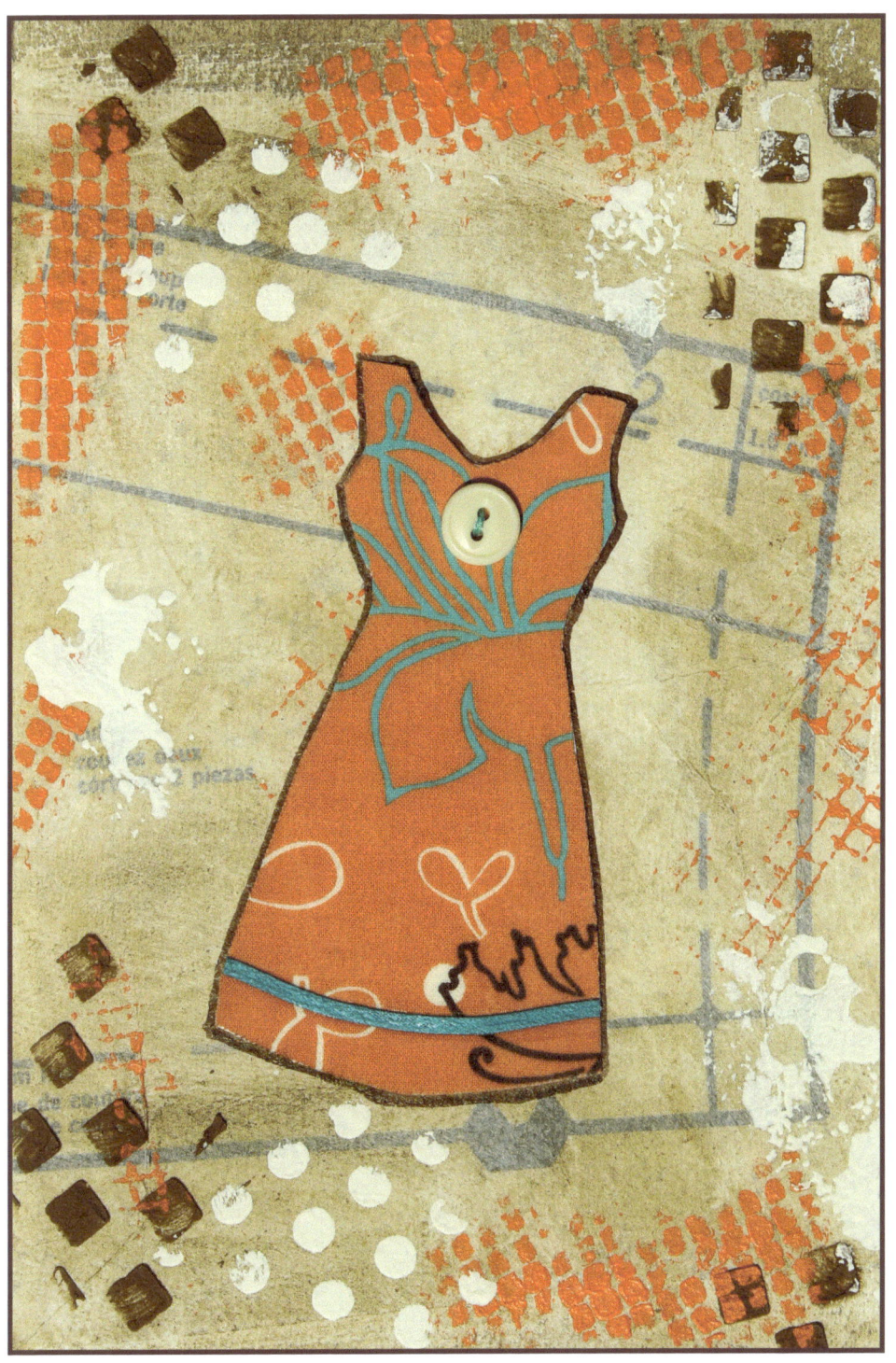

Kayla moved to Easter Island.

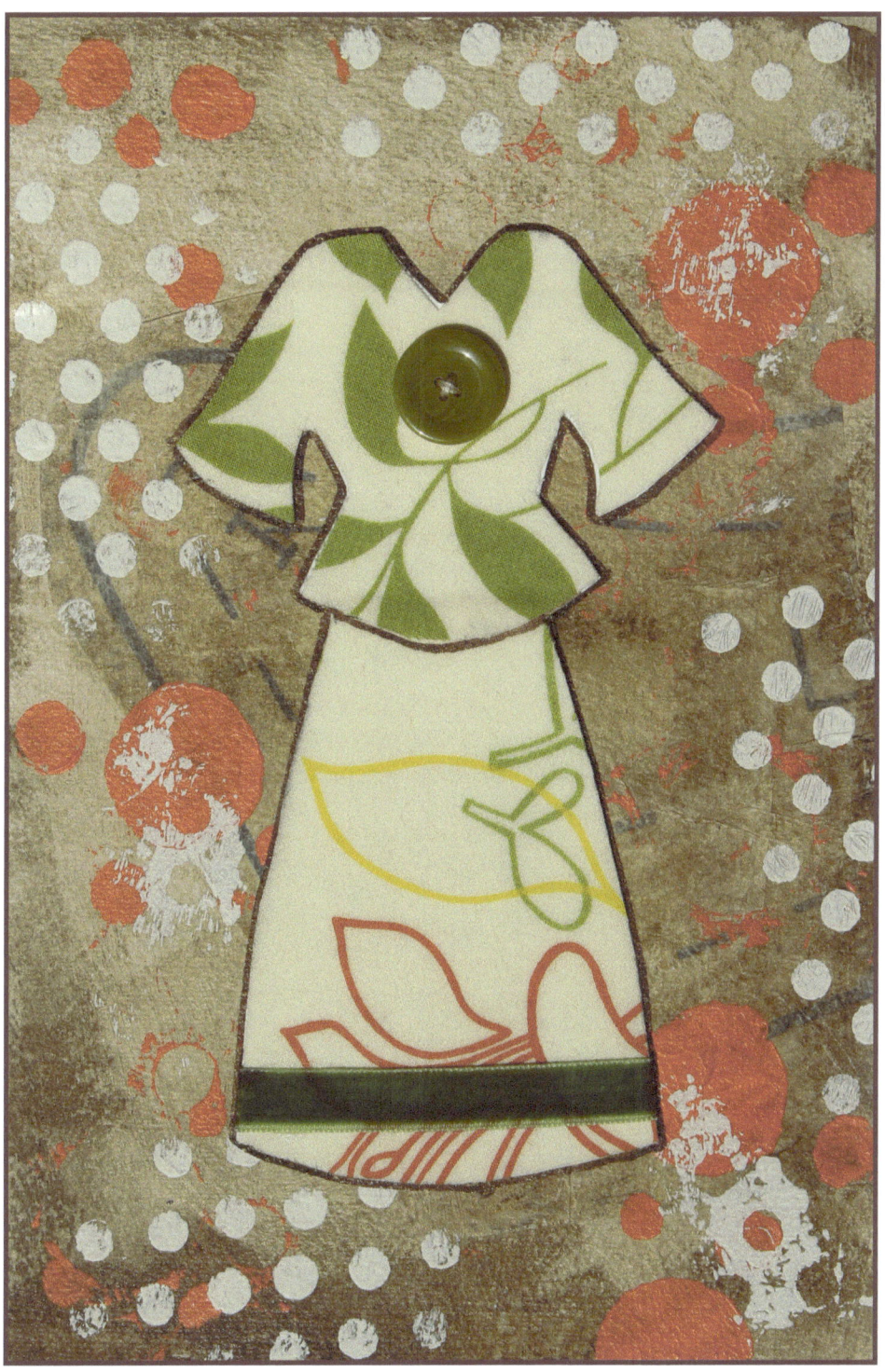

Lavonne lost 10 pounds when she stopped eating.

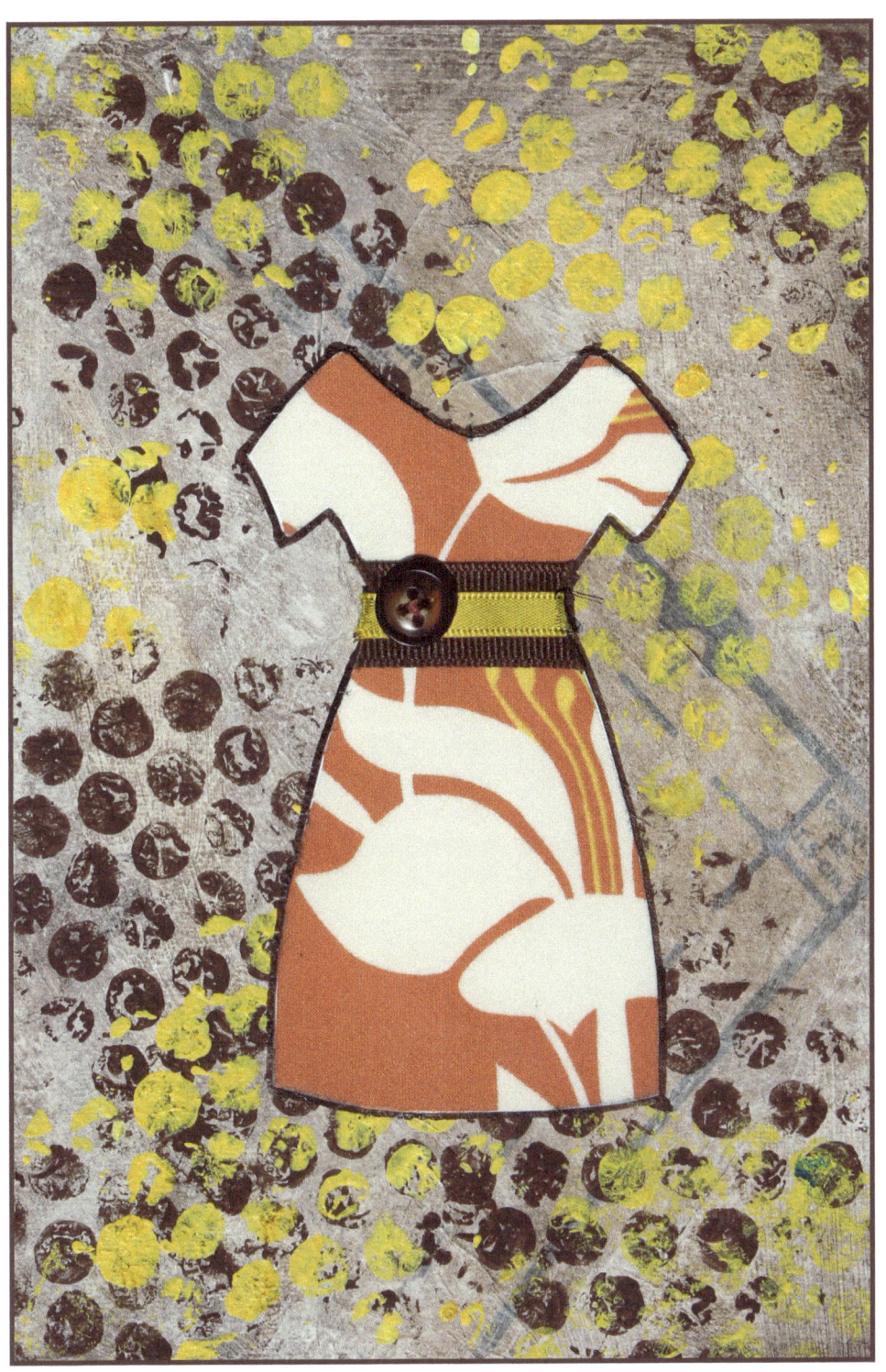

Maggie gained 10 pounds when she stopped smoking.

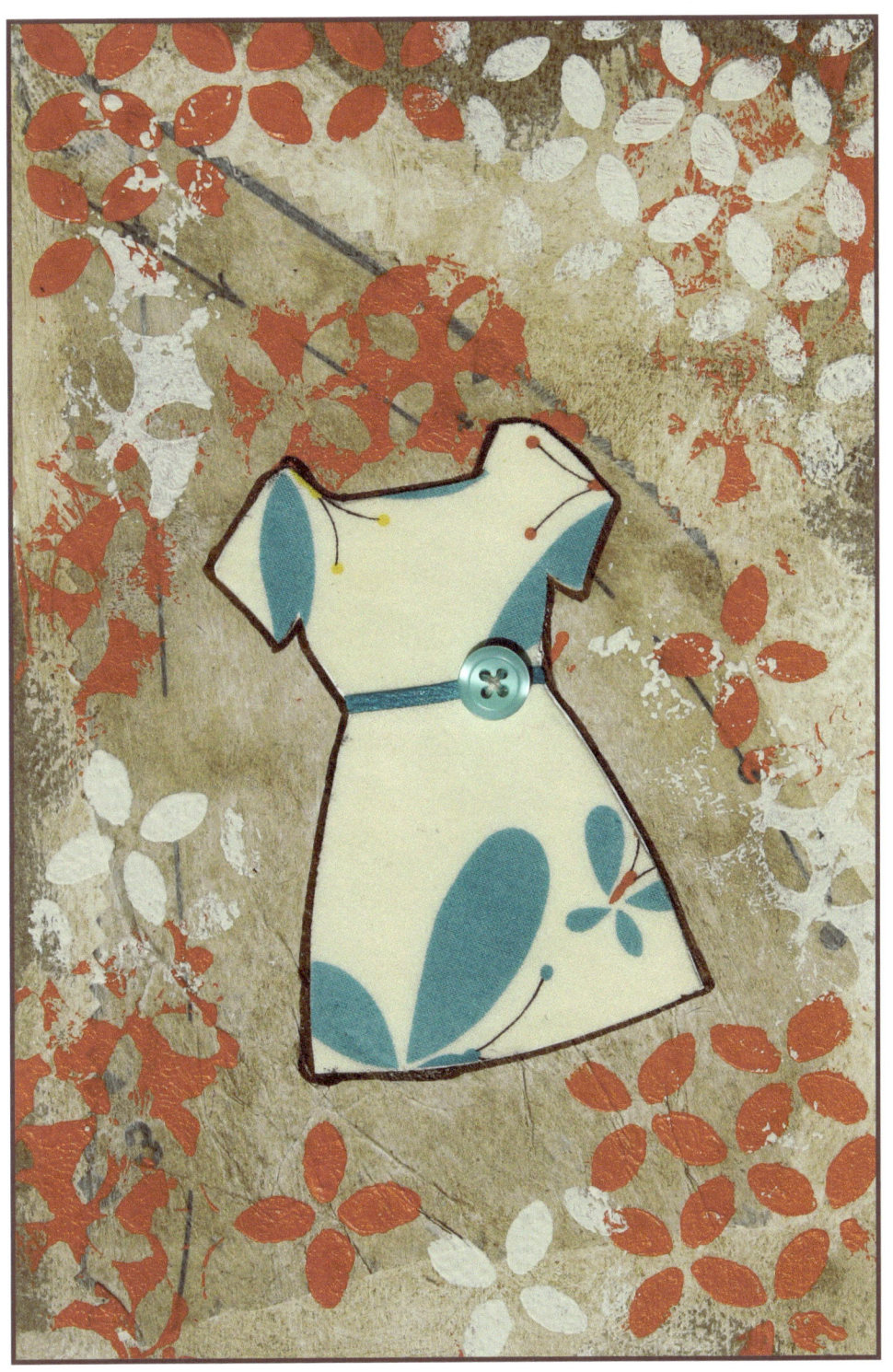

N

Nancy realized she was no longer a girl detective.

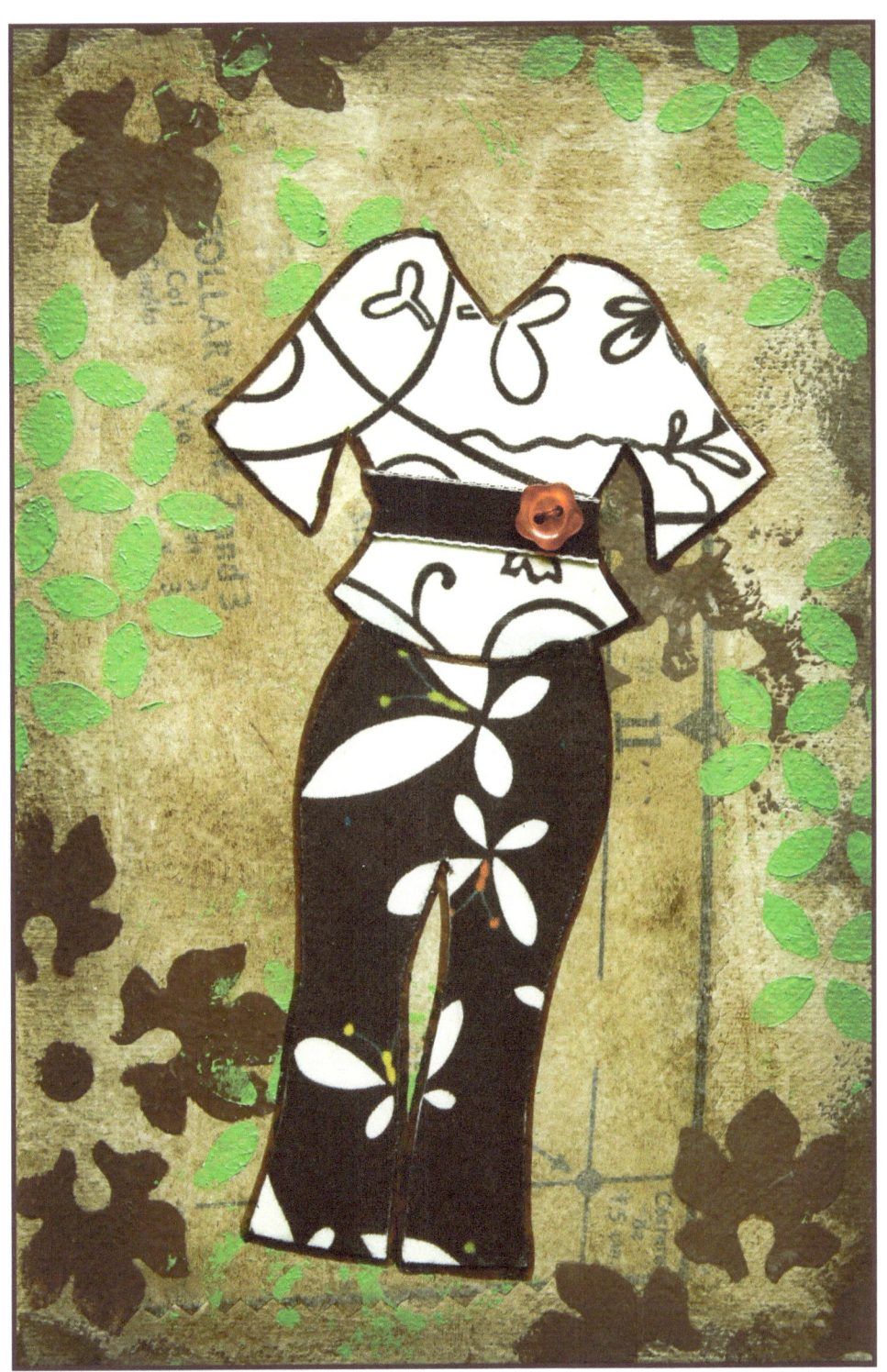

Olivia gave up on scrapbooking.

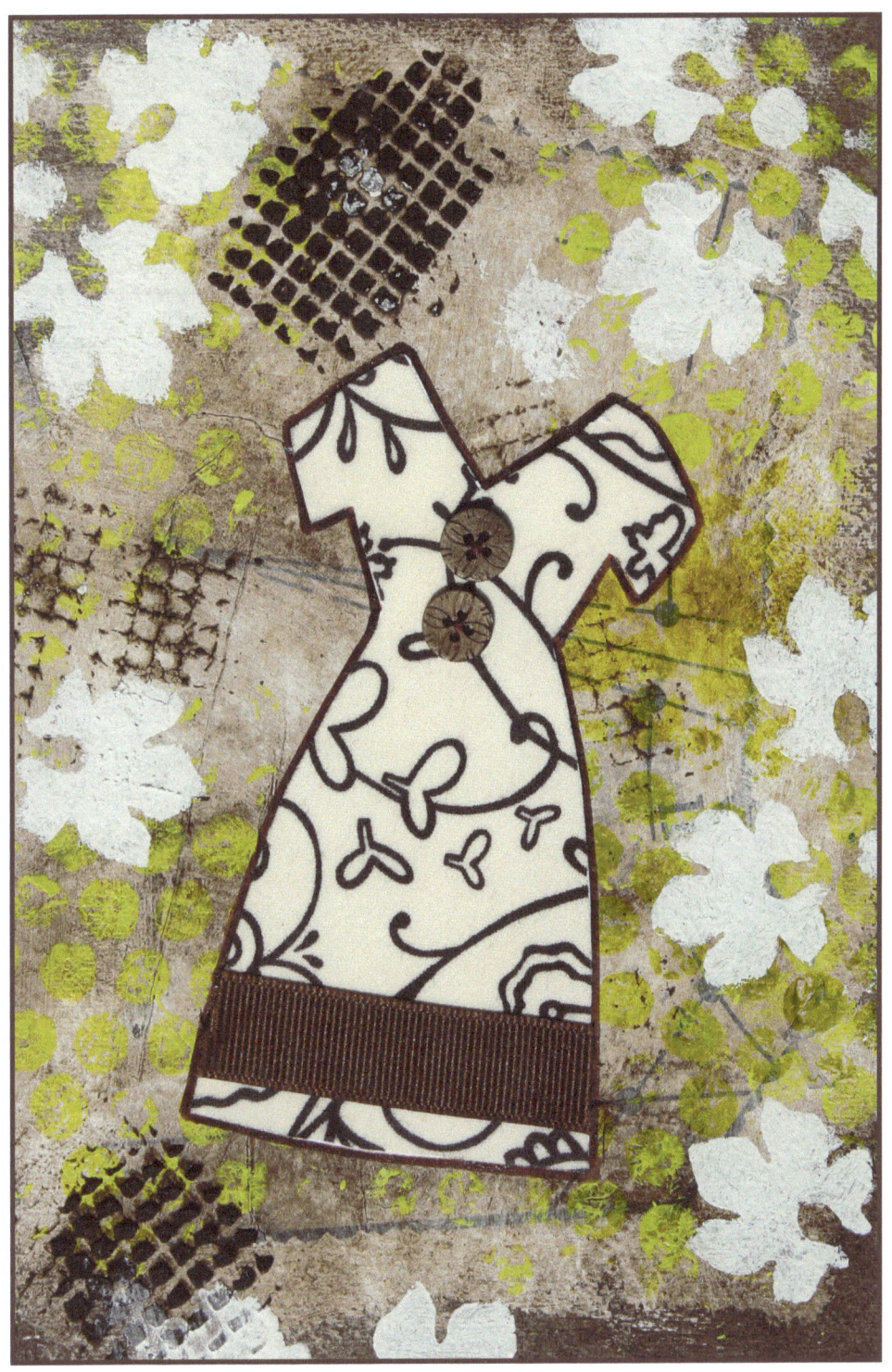

P

Penny became allergic to her cats.

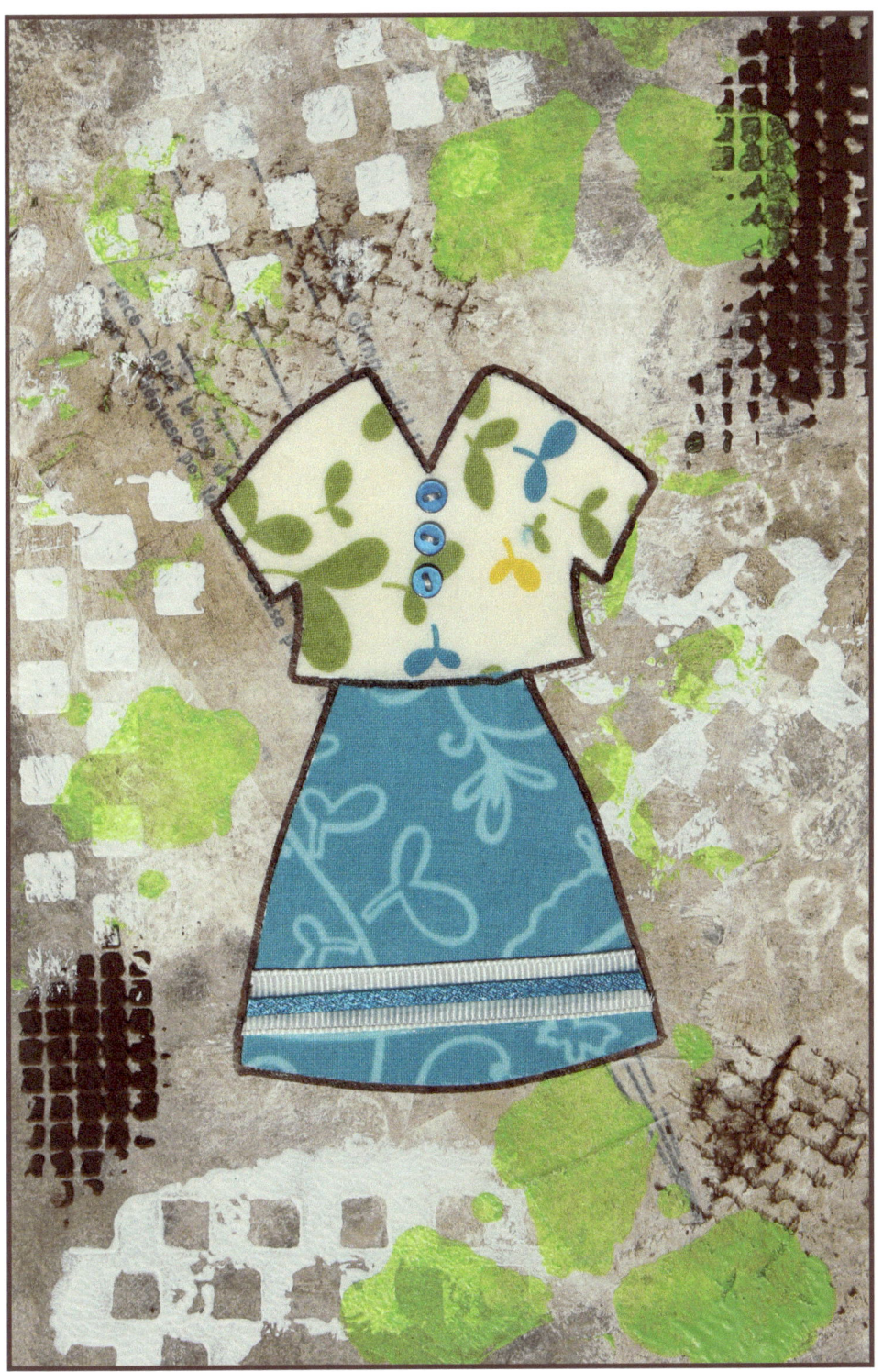

Queenie started buying lottery tickets.

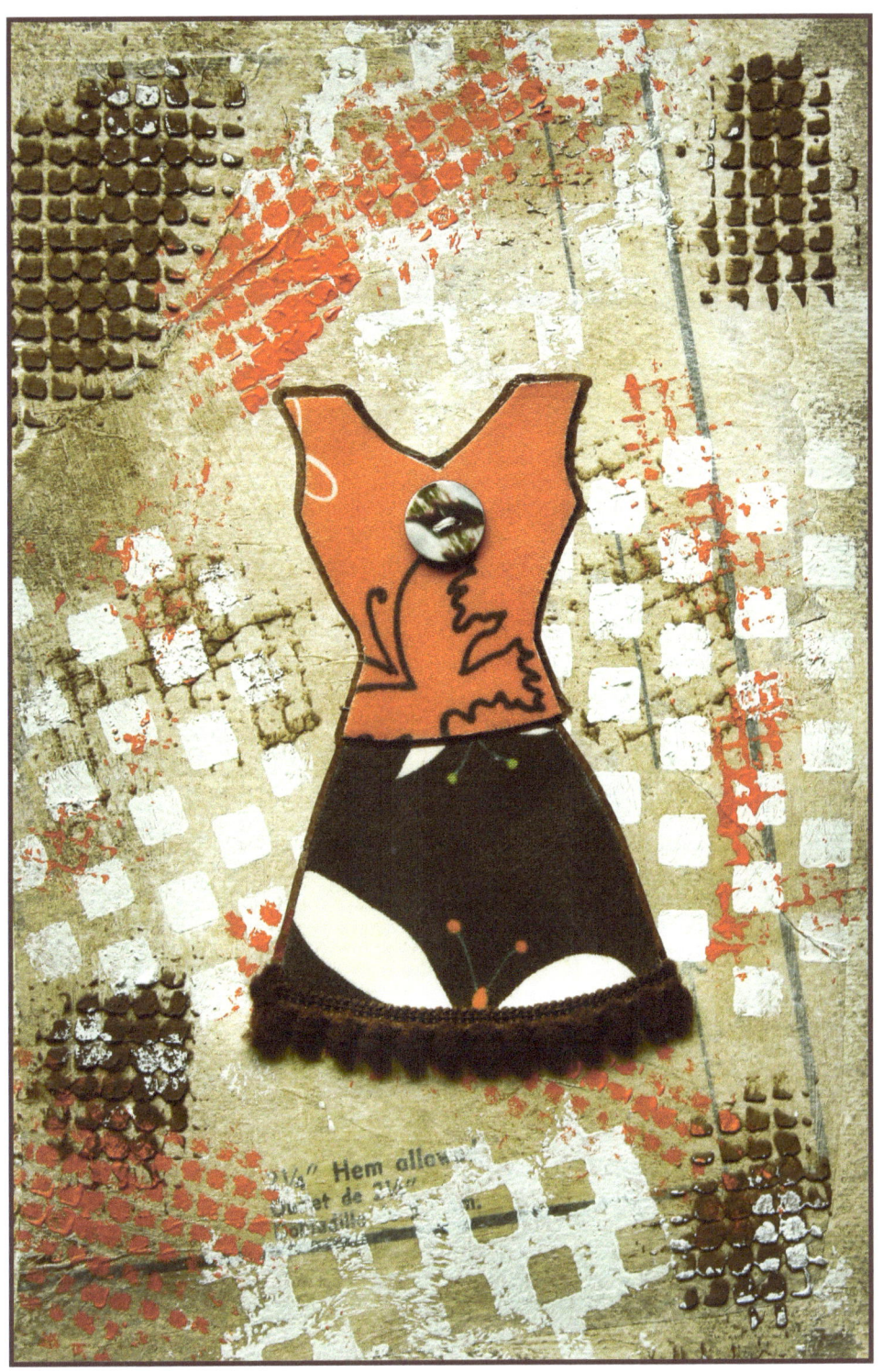

R

Ramona tossed her
"to do" list in the garbage
and never looked back.

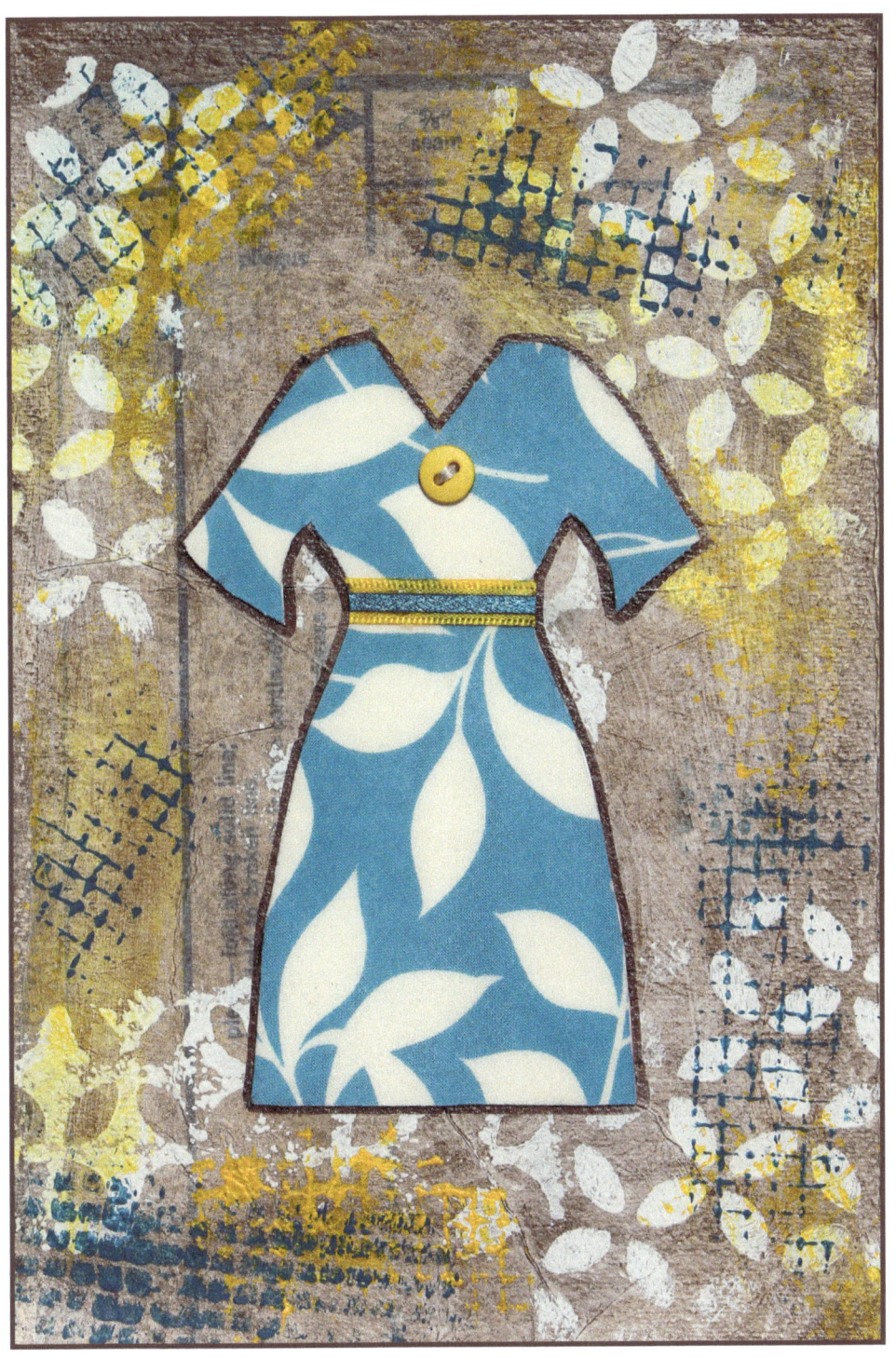

Sheila ran off with the circus.

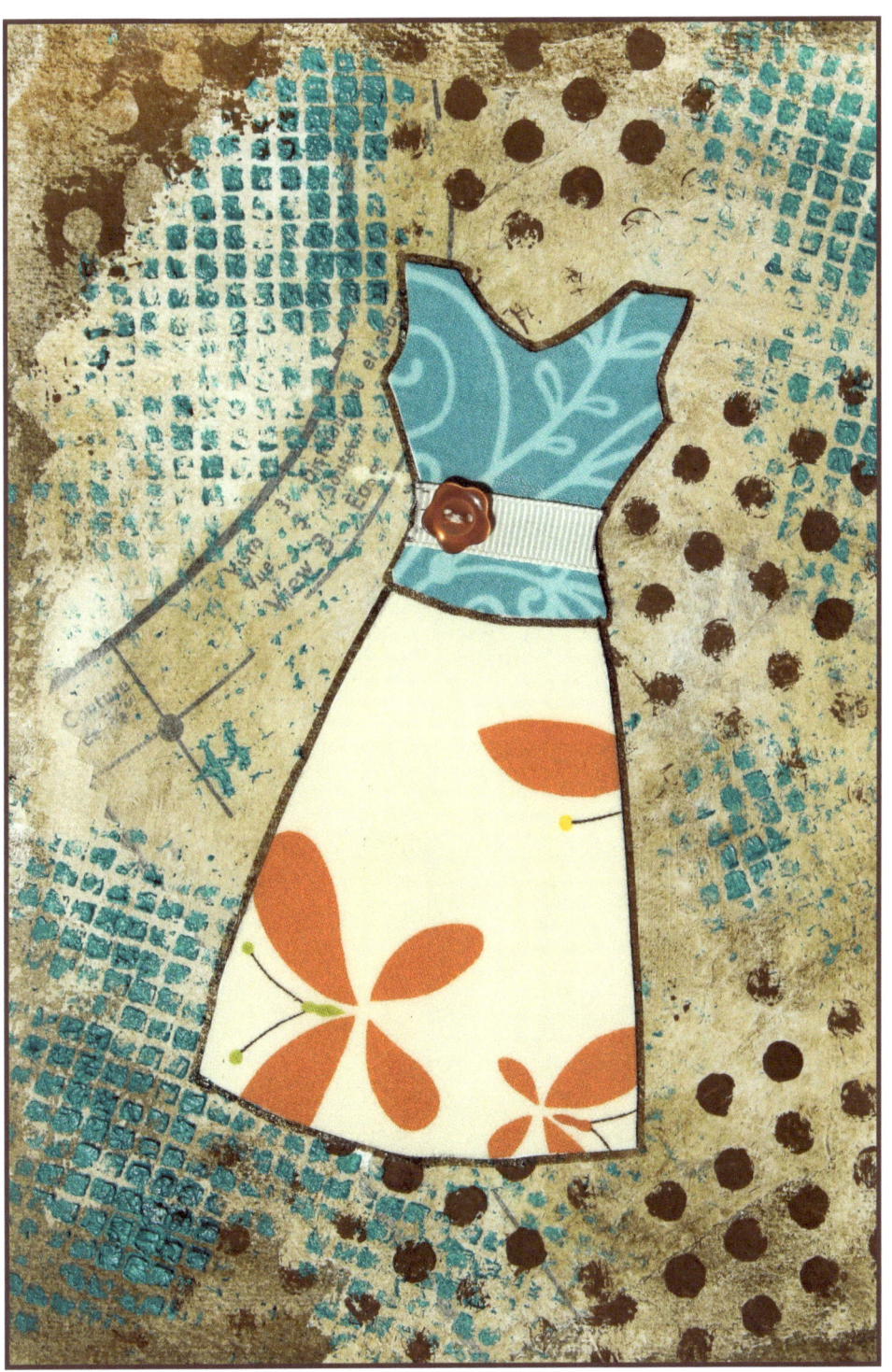

Tamara became a cartographer.

U

Uma bought a yellow pant suit (which is not shown here).

V

Vilma started hanging out at the courthouse.

W

Wendy was horrified to realize
how many calories were in
a bottle of Riesling.

Xena became a warrior princess.

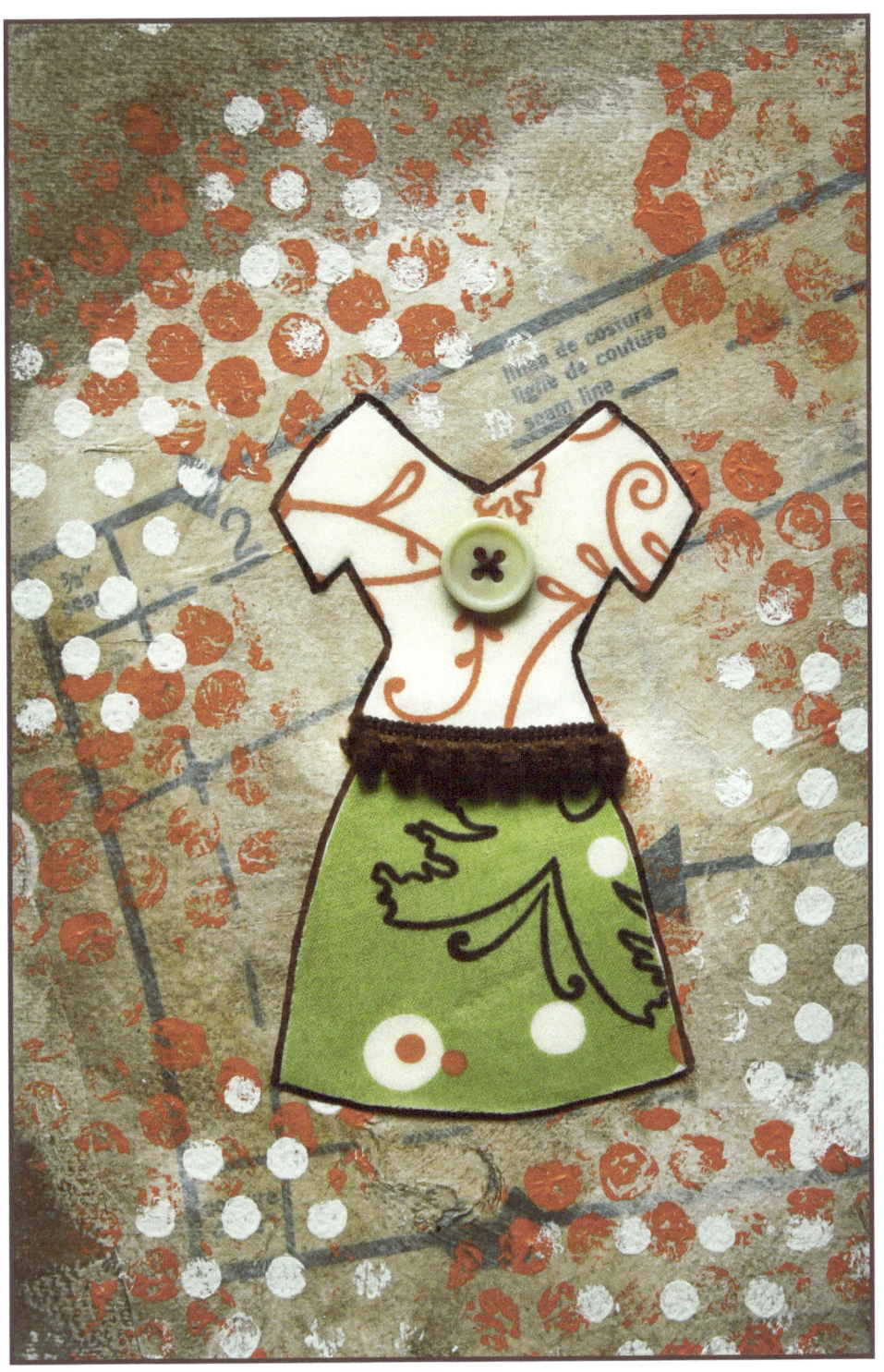

Y

Yvonne figured out how to calculate the required return for a preferred stock.

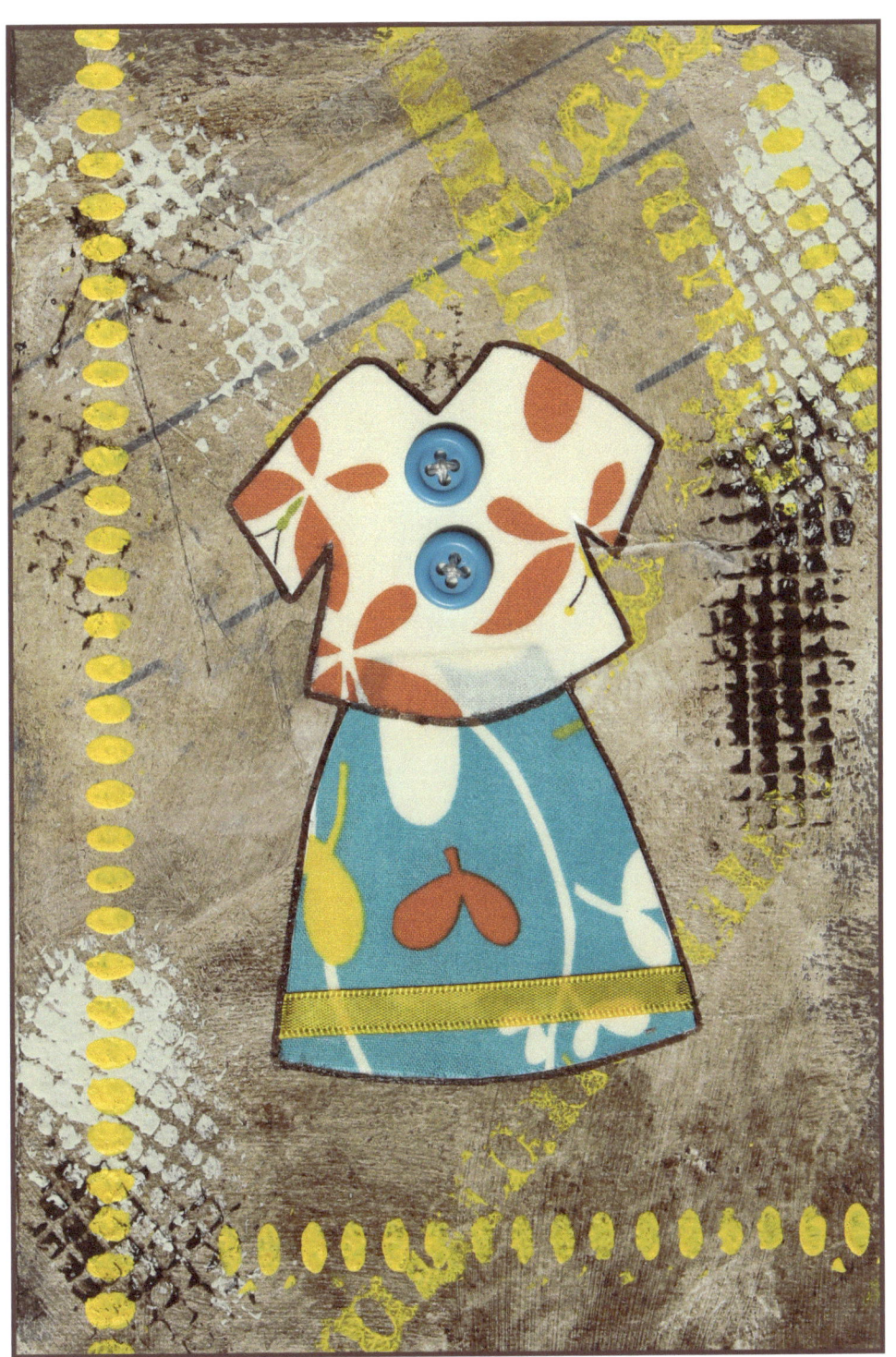

Z

Zelda accepted the fact that
she would never
read "War and Peace."

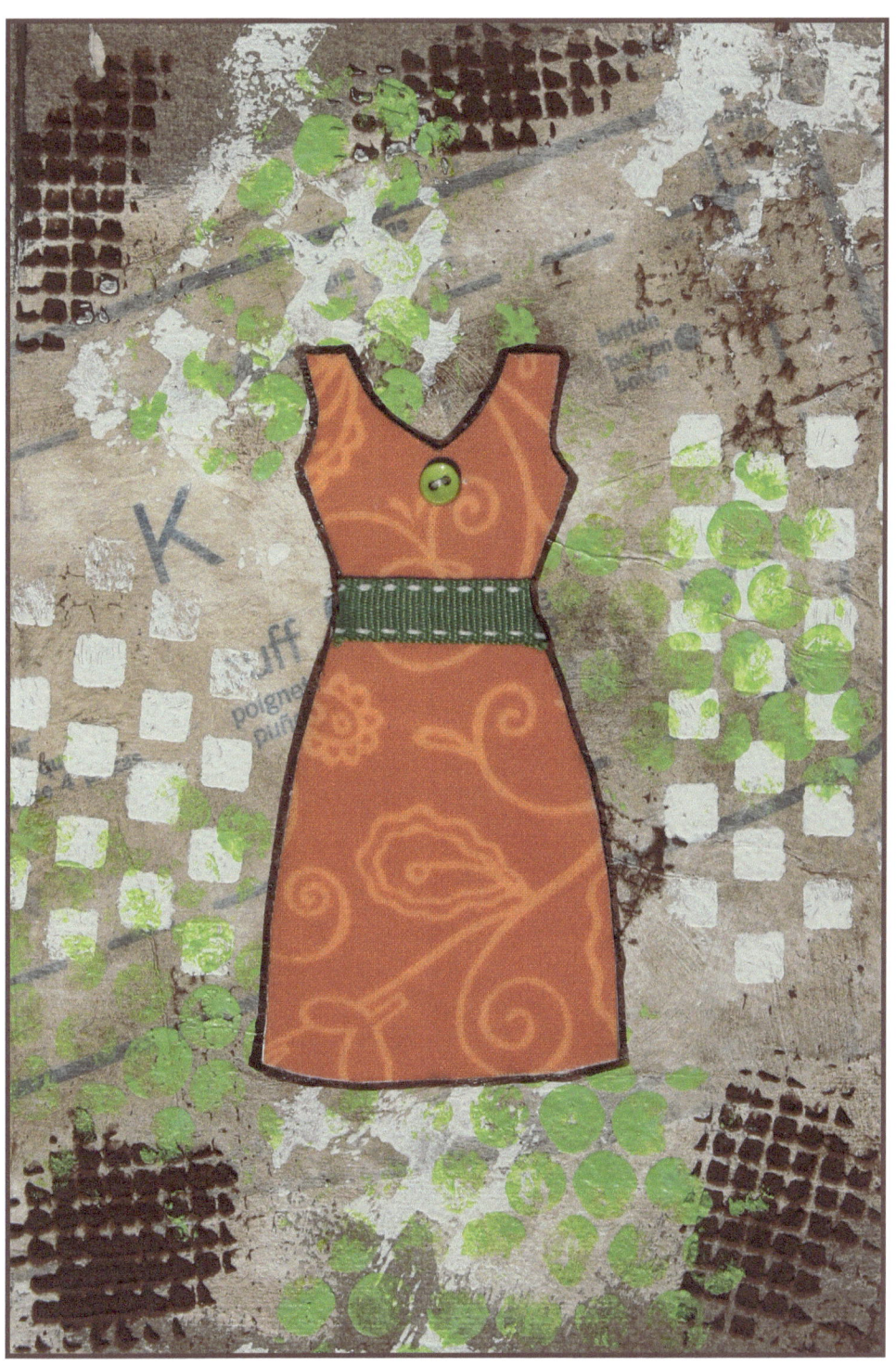

I would love to hear what **you** did when you turned 40-ish.

Stop by Facebook at
www.Facebook.com/StrangeFarmGirl
and let me know!